Ernst Ludwig Kirchner

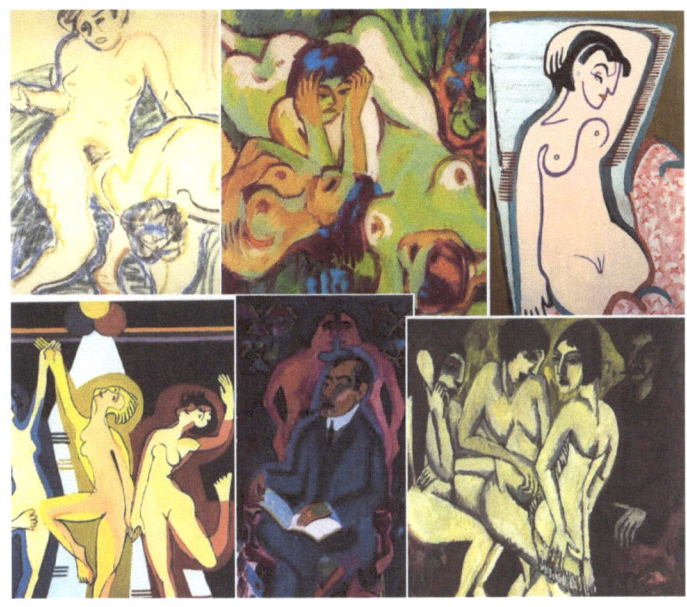

Edited By Lacey Belinda Smith

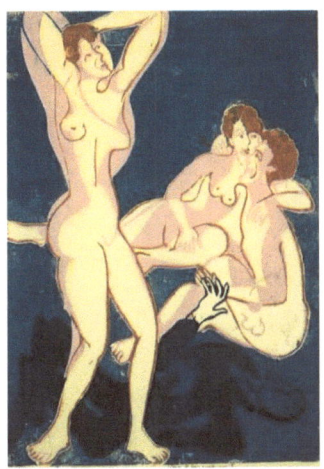

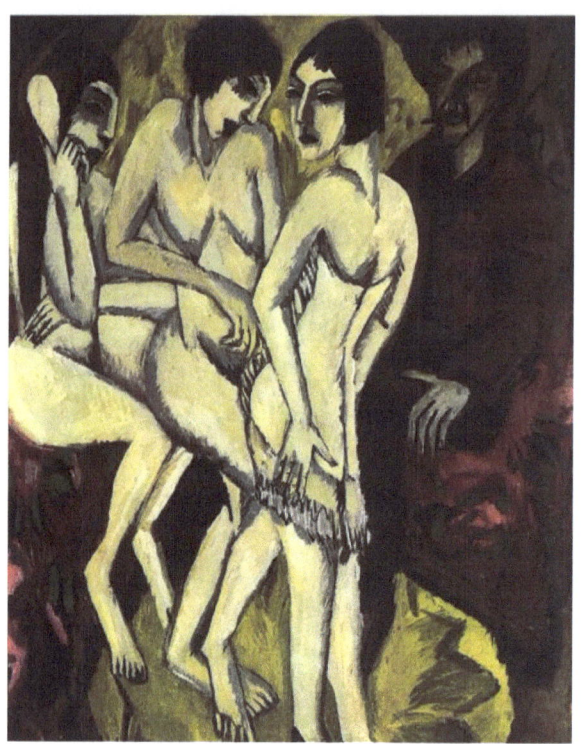

The Choice of Paris

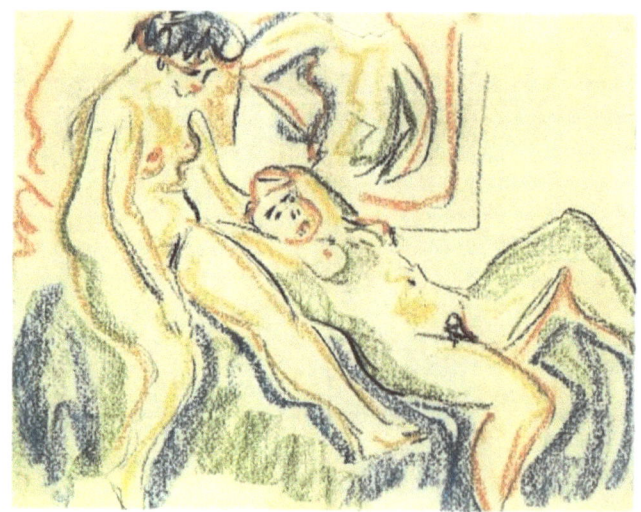

Two Female Nudes At A Couch

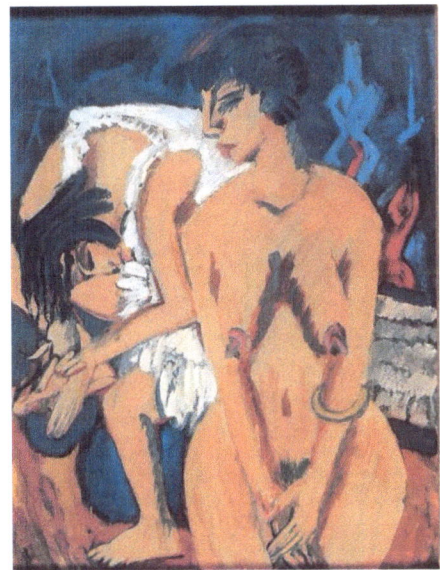

Women

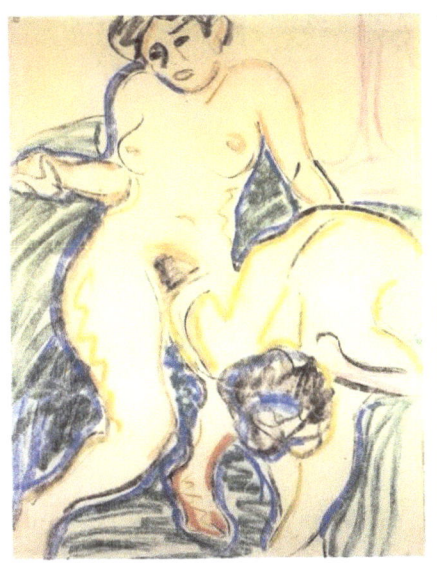

Two Nude Girls

Ernst Ludwig Kirchner (1880–1938) was a painter and printmaker born Aschaffenburg, Germany. He was a leading force behind the Expressionist movement in Germany. Kirchner was influenced by the work of Vincent van Gogh, Gustav Klimt, Edvard Munch, the Fauves, Japanese prints, African, and Oceanic art. He volunteered for army service in World War I, but soon he suffered a breakdown and was discharged from the army. The Nazis régime defamed his work as—degenerate--in 1937. They confiscated all of his paintings which were on display in public museums. In 1938 he committed suicide by a gunshot.

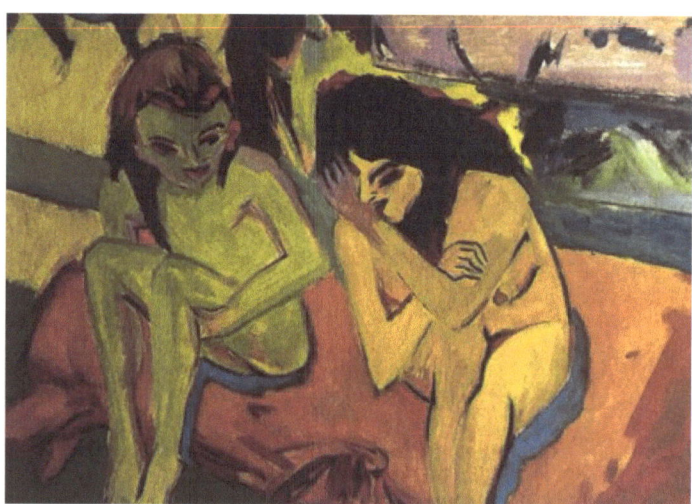

Two Girls 1907

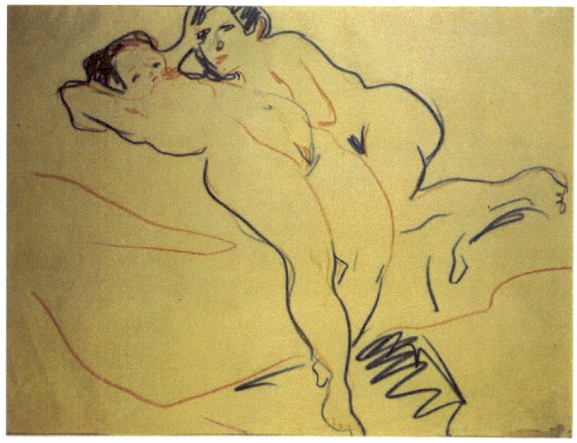

Couple

1907—1908

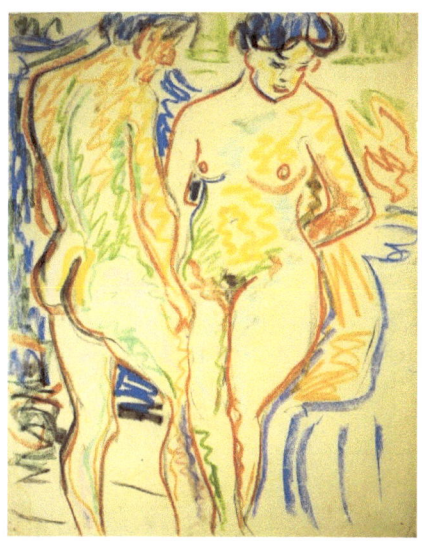

Couples 1908

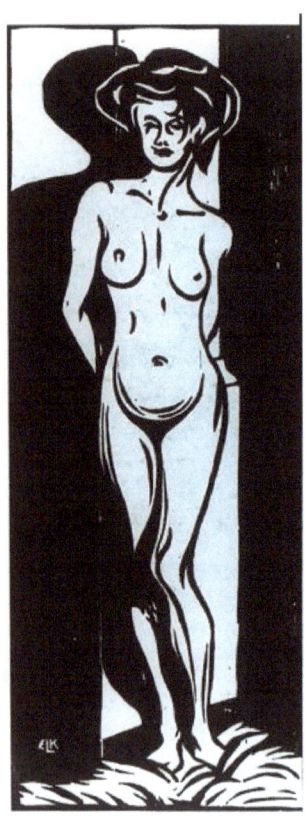

Nude Young Woman In Front Of A Oven—1905

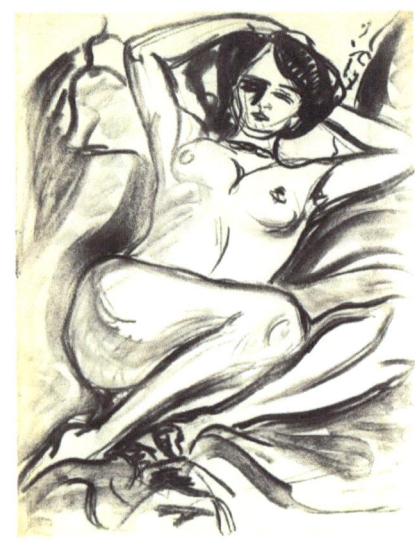

Reclining Nude (Isabella)--1906

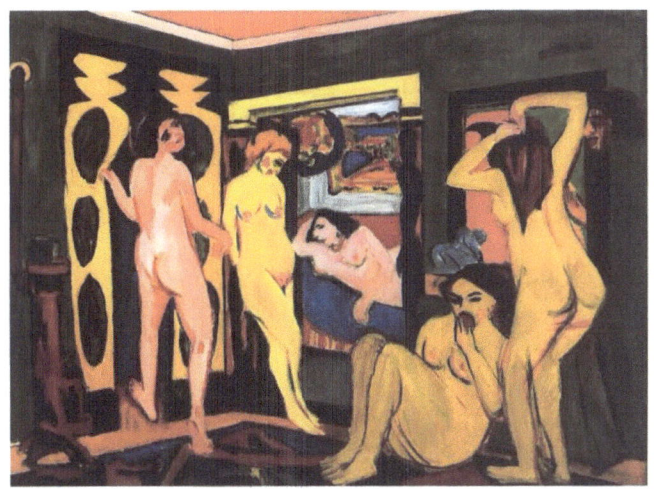

Bathing Women In A Room-- 1908

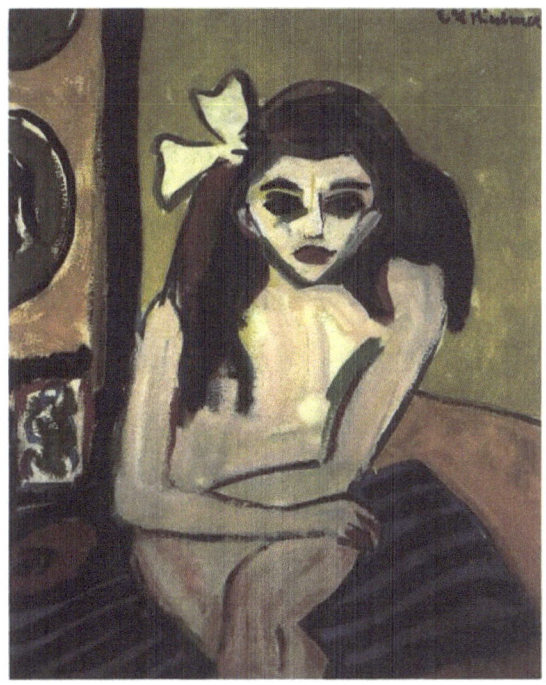

Macrella--1909

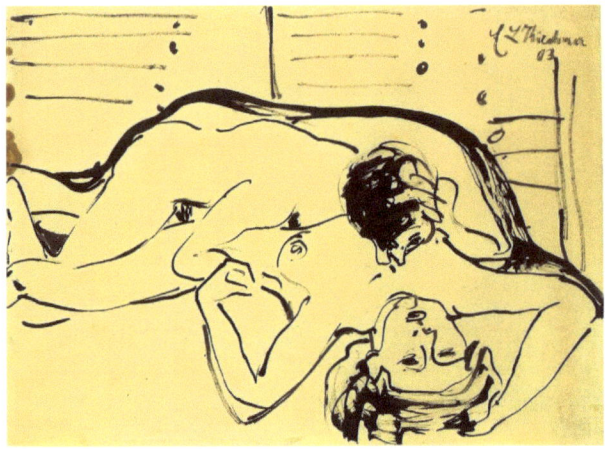

Lovers--1909

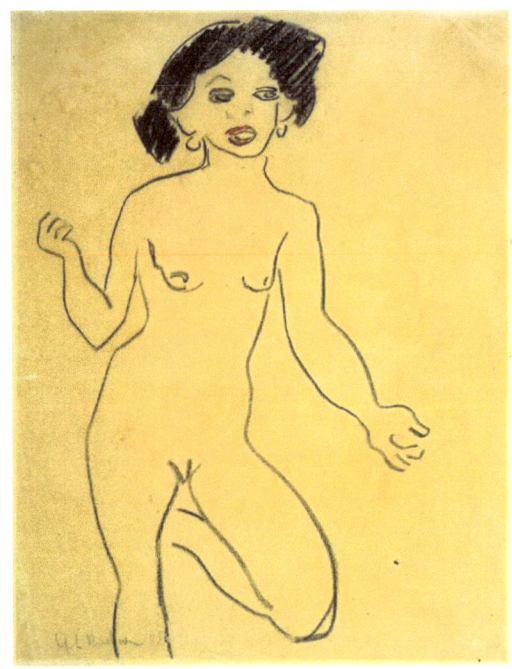

Milli--1909

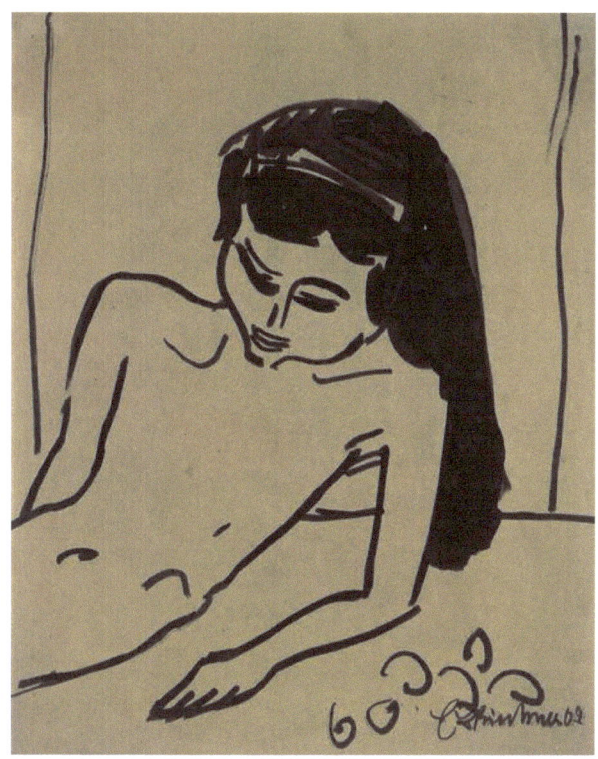

Girl With Long Hair--1909

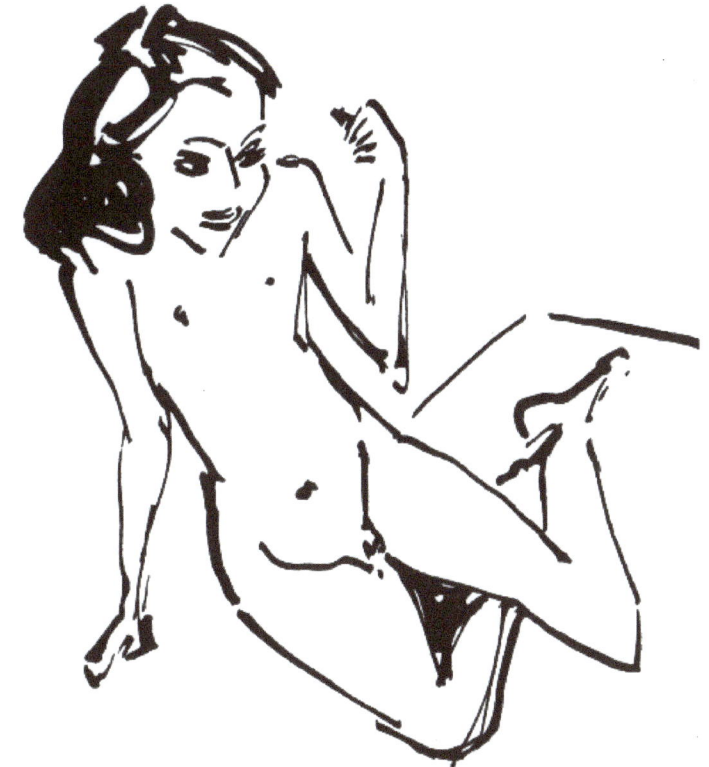

Small French--1909

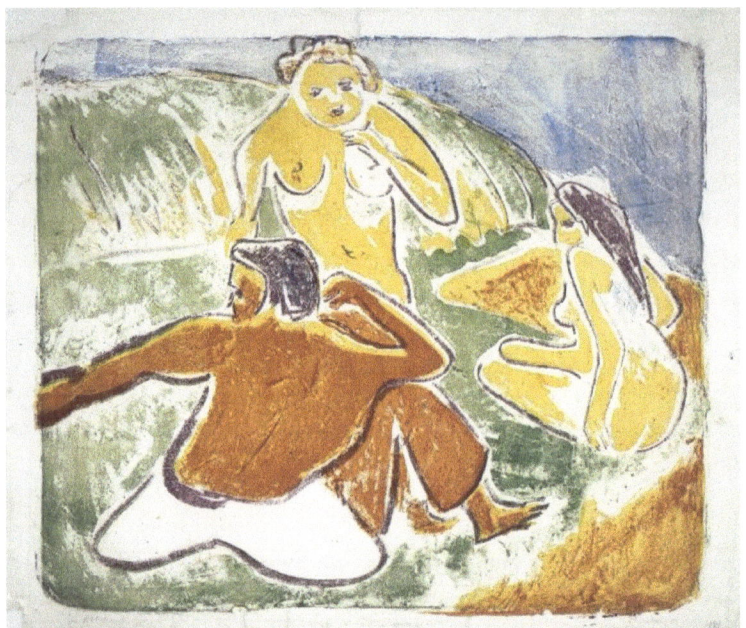

Three Bathers On The Beach--1909

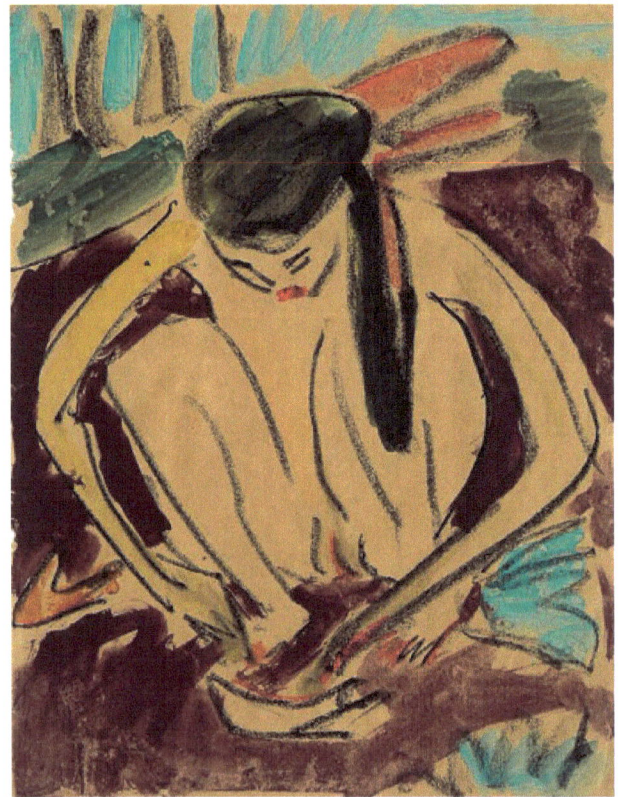

Crouching Girl--

1909

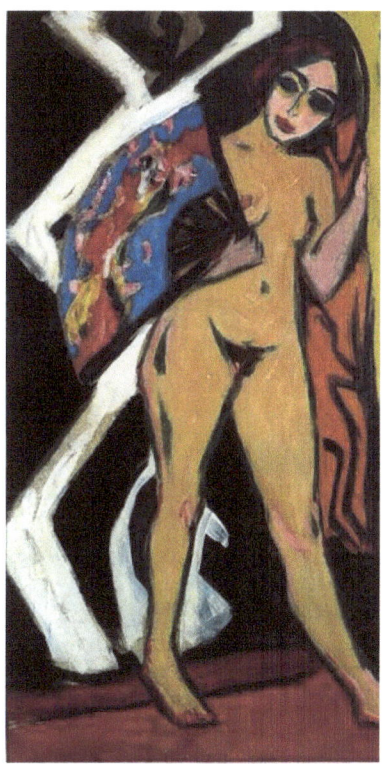

Dodo With Large Fan--Date: 1910

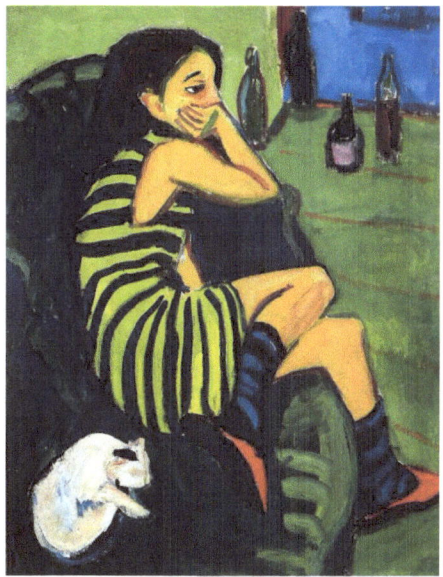

Female Artist--1910

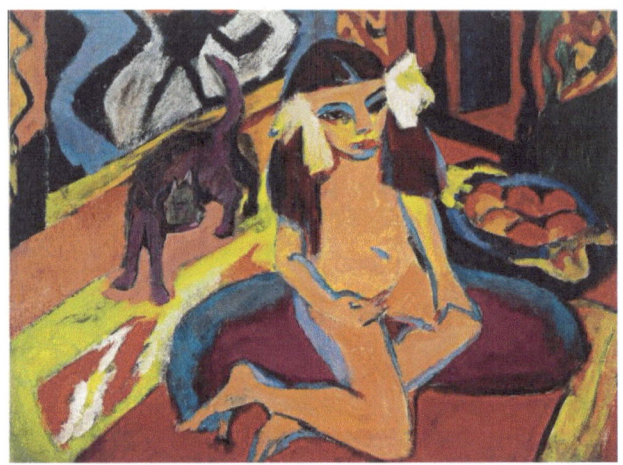

Girl With Cat (Franzi)--1910

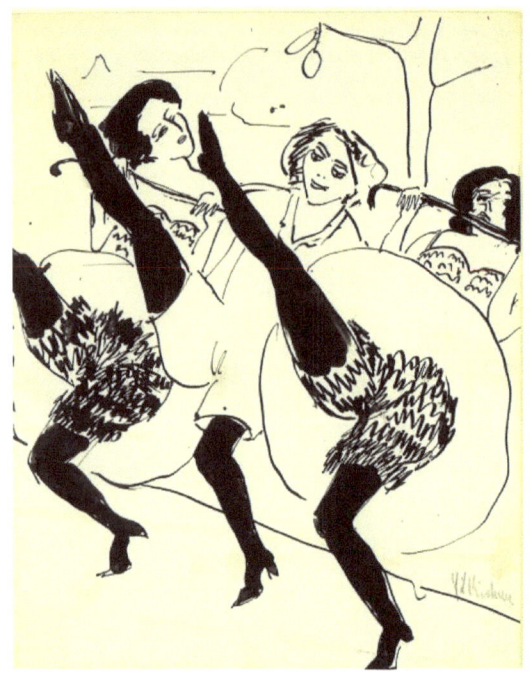

Hamburg Dancers

1910

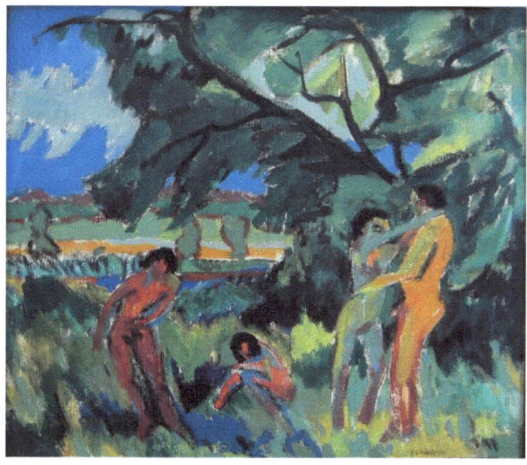

Playing People--1910

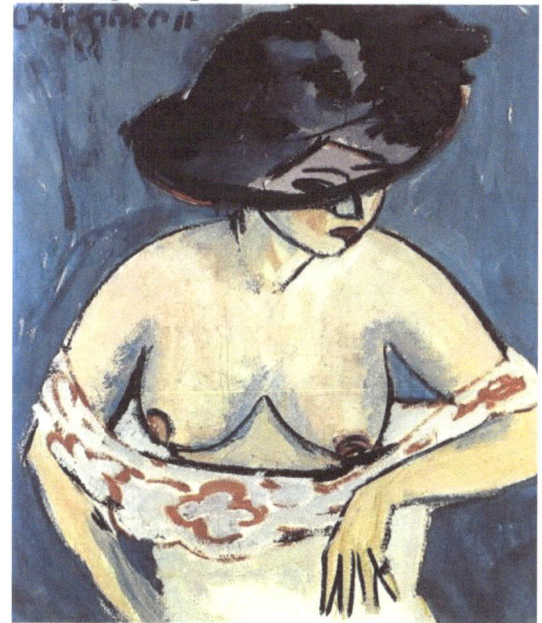

Half-Naked Woman With A Hat--1911

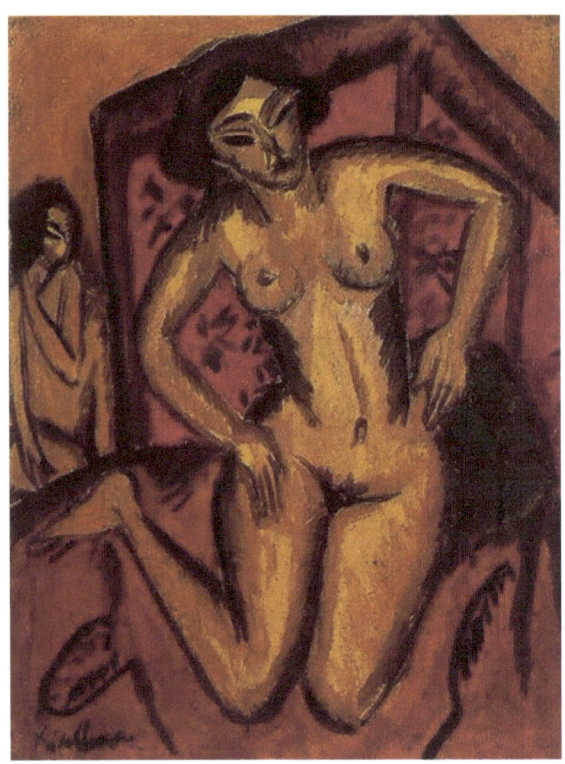

Female Nude Kneeling Before A Red Screen--1912

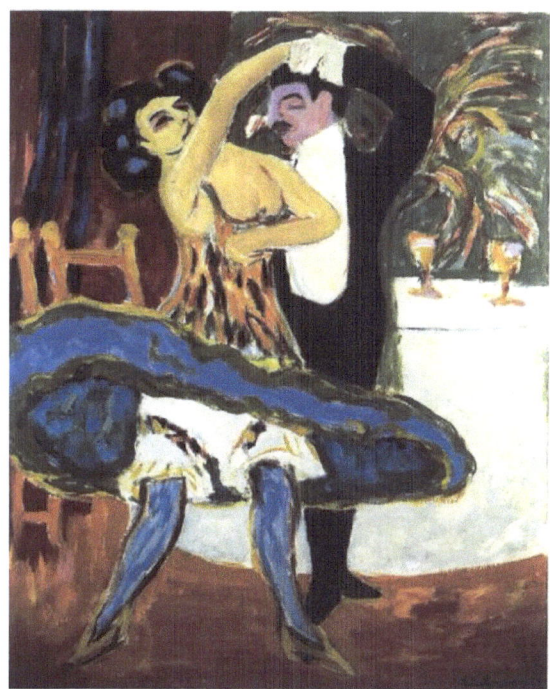

English Dance Couple

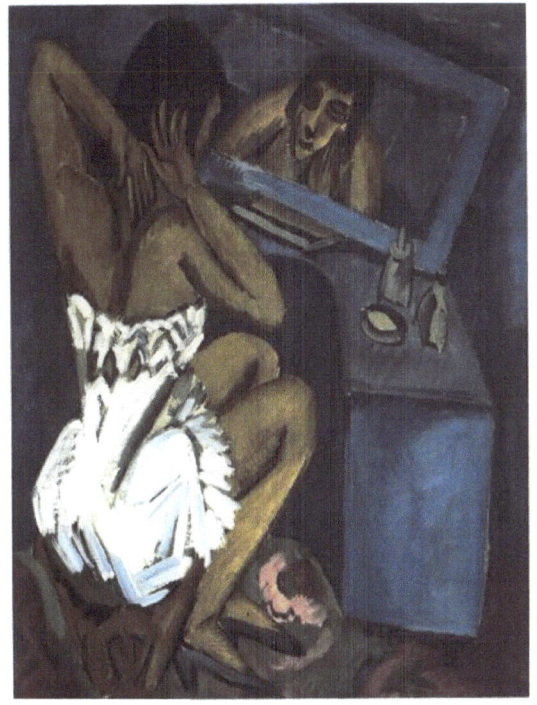

Woman Before The Mirror--
1912

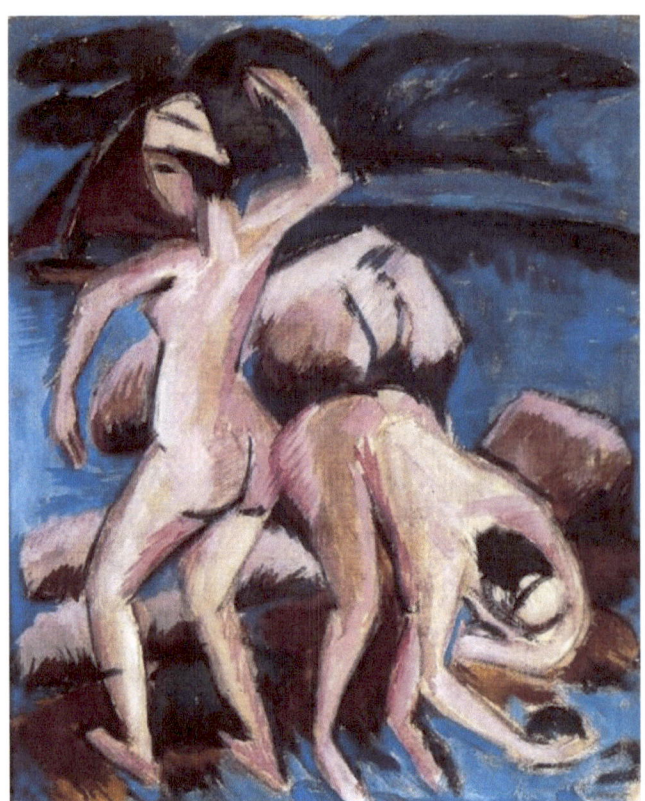

Two Bathers--

1912

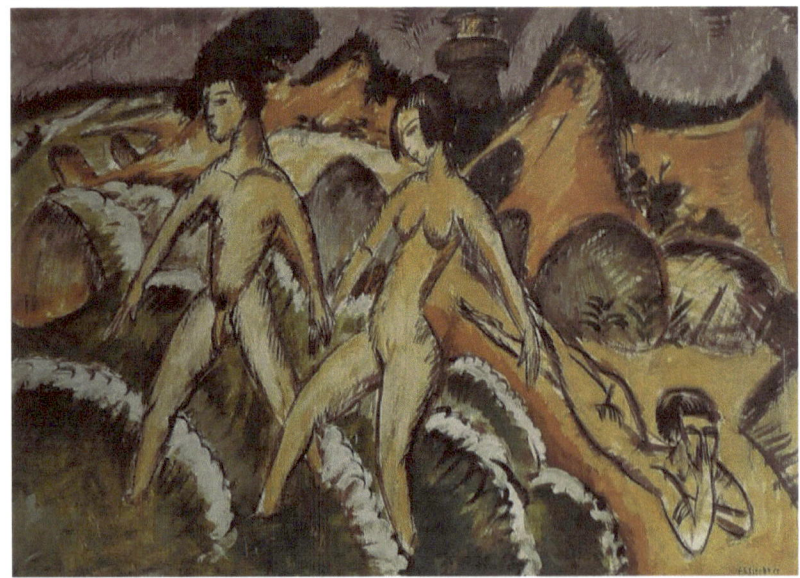

Female Nudes Striding Into The Sea--

1912

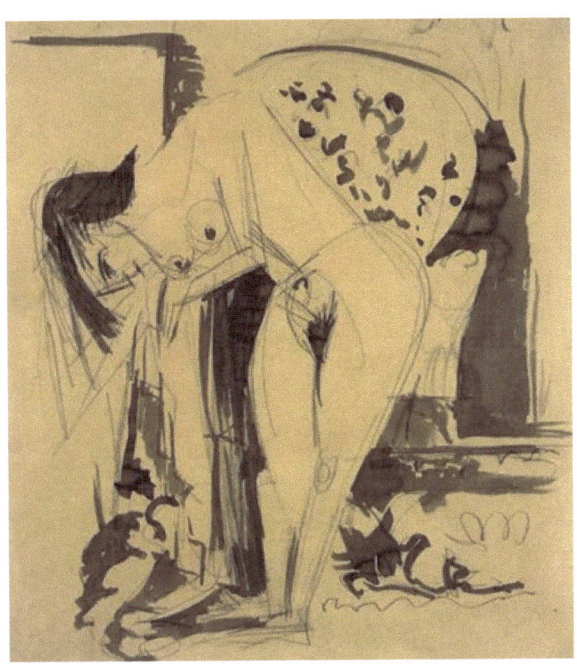

Stooping Act In Space--

1912

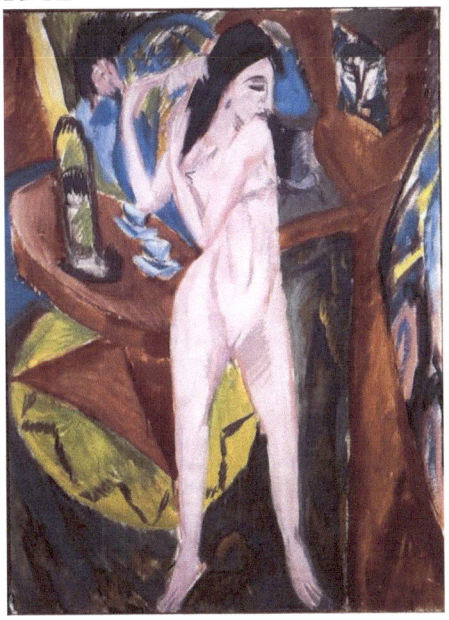

Nude Woman Combing Her Hair--

1913

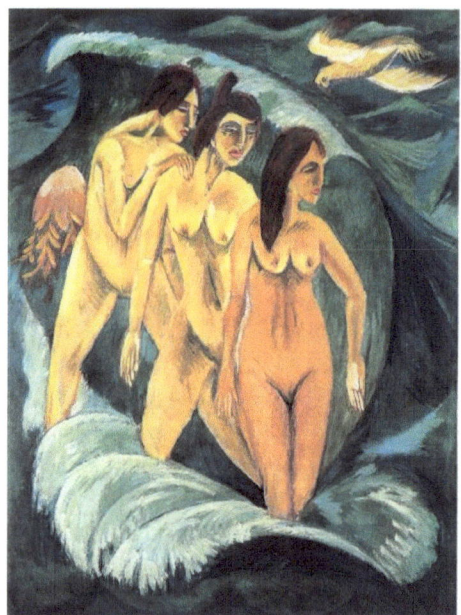

Three Bathers--1913

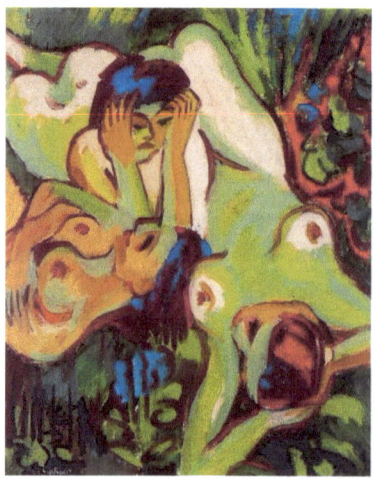

Bathers On The Lawn--1914

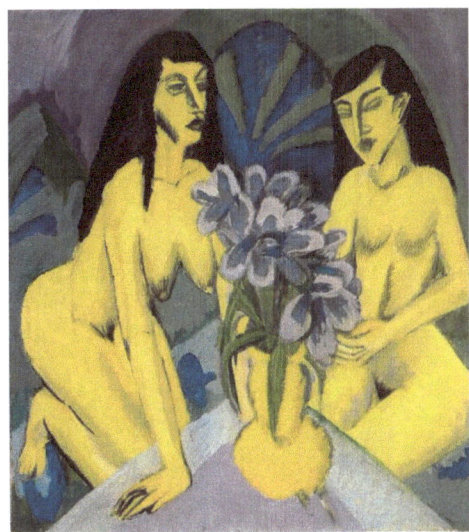

Two Yellow Knots With Bunch Of Flowers--1914

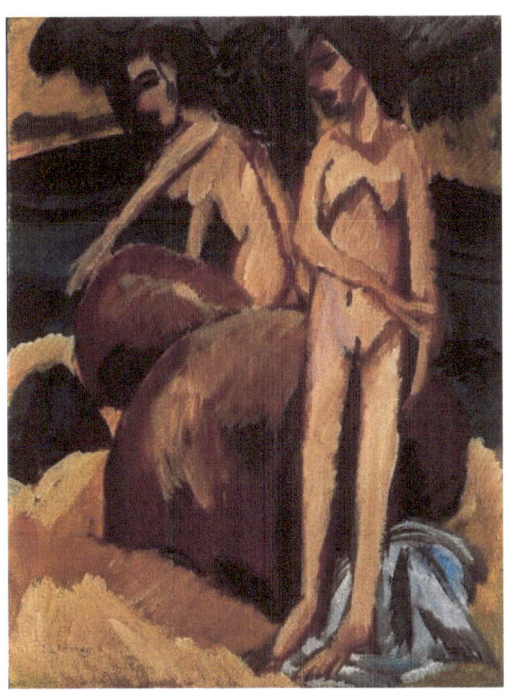

Bathers at Sea--1914

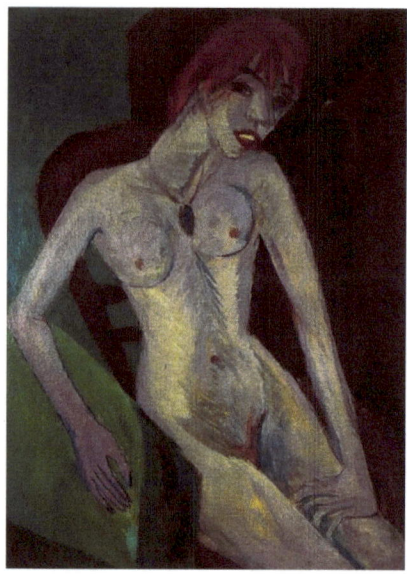

Capelli Rossi (Red Hair)--
1914

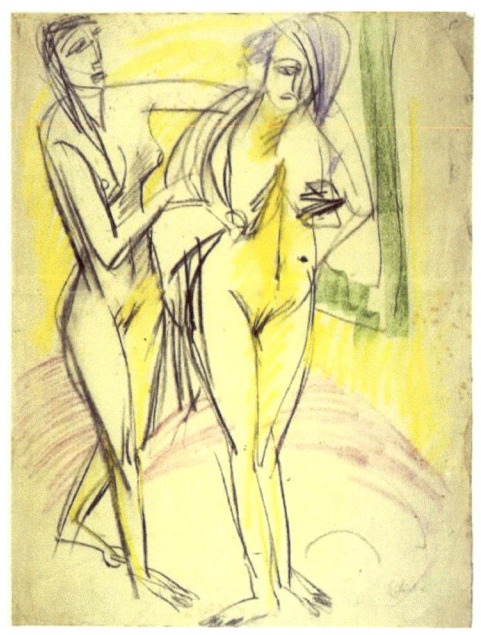

After the Bath –1914

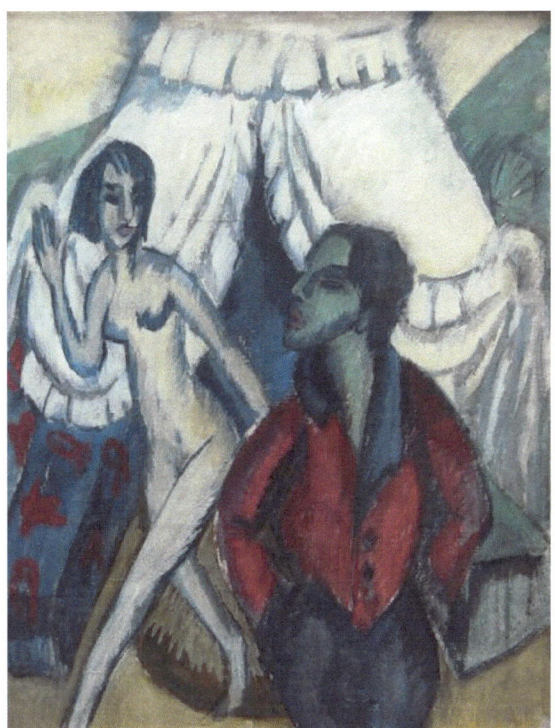

The Tent--1914

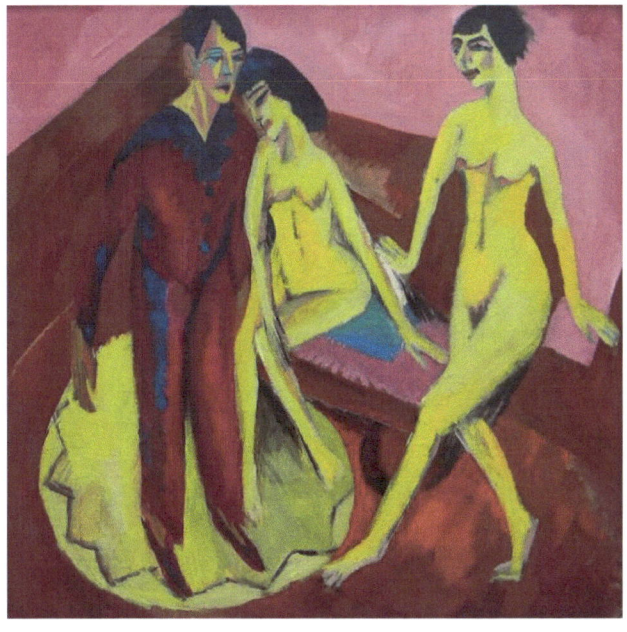

Dance School--1914

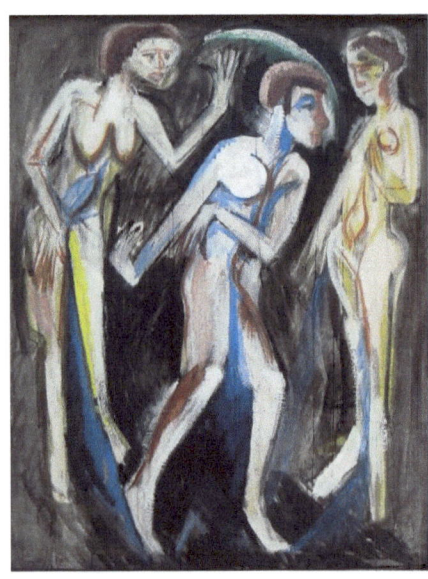

The Dance Between The Women--
1915

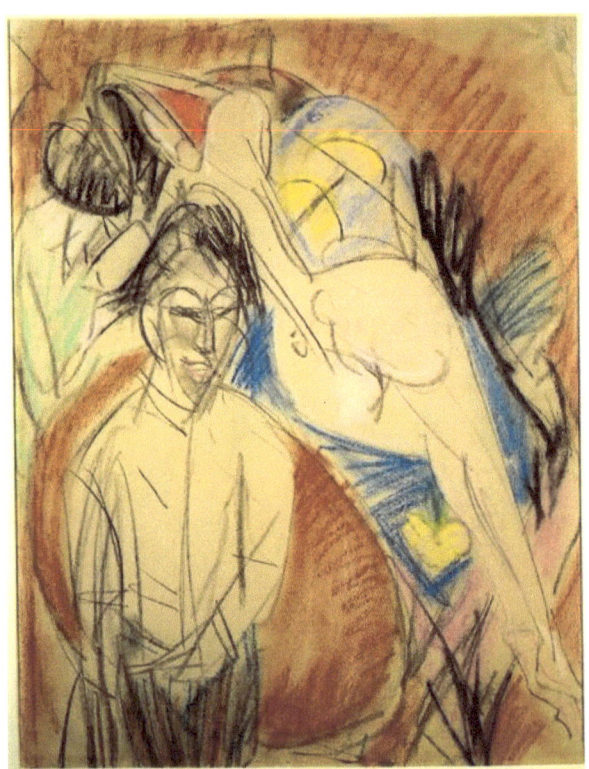

Man And Naked Woman--
1915

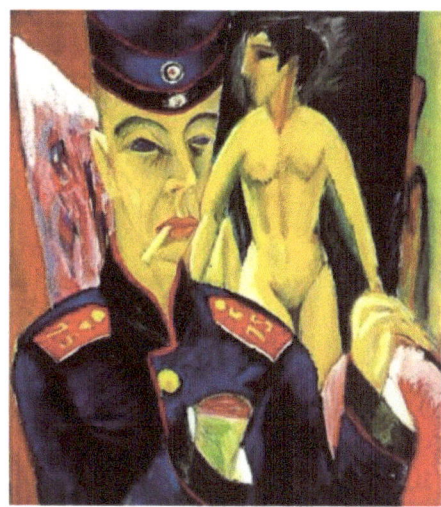

Self Portrait as a Soldier - Ernst Ludwig Kirchner--1915

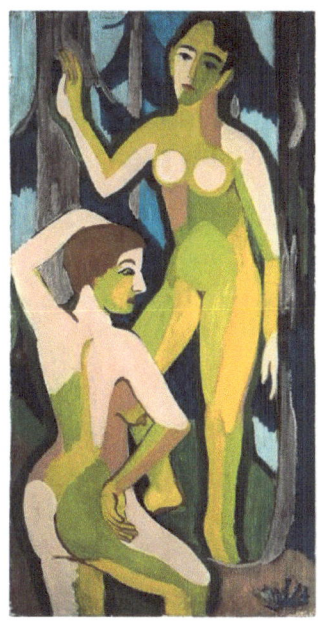

Two Nudes In The Wood II--1926

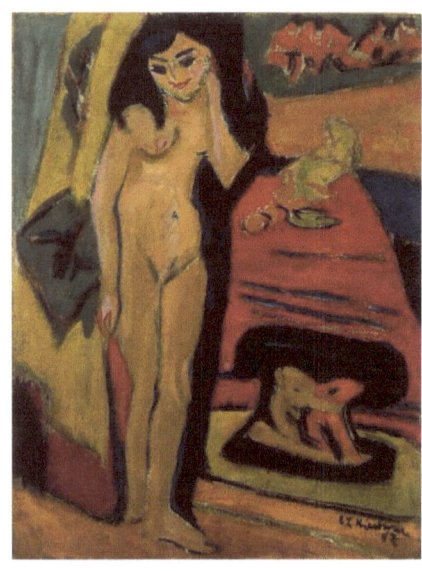

Naked Girl Behind The Curtain (Franzi)
1910—1926

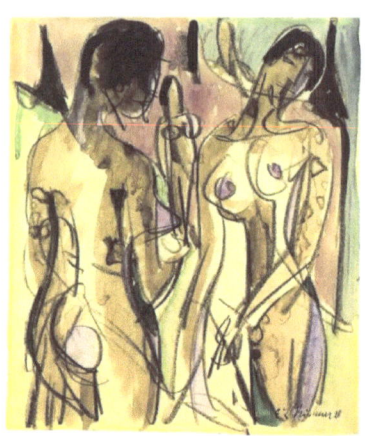

Three Nudes In The Forest—1928

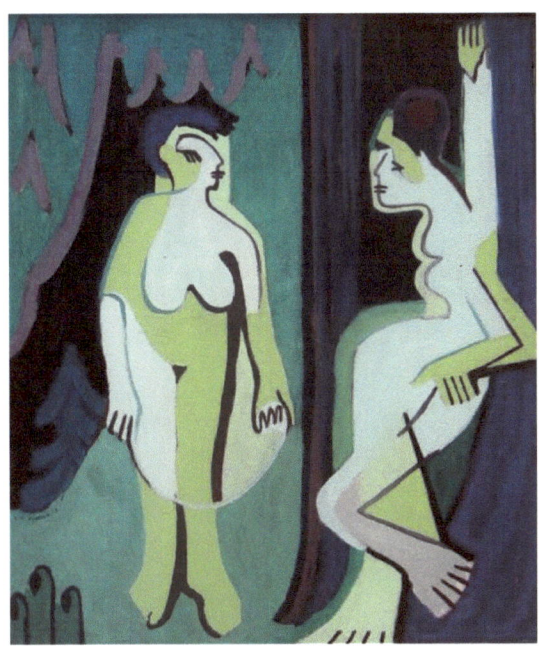

Naked Women On Meadow--
1928

Entcounter--1929

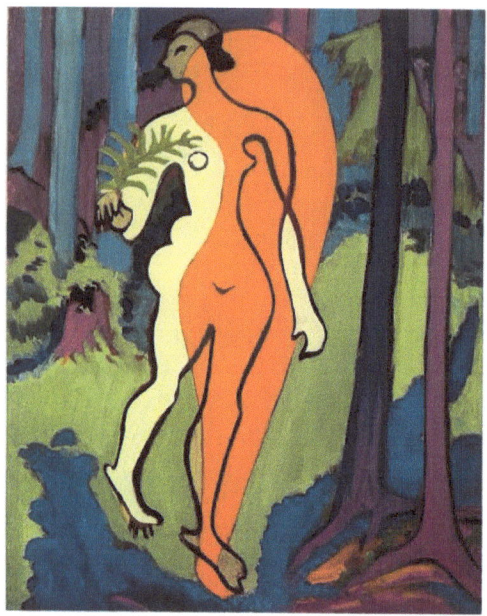

Nude In Orange And Yellow
1929--1930

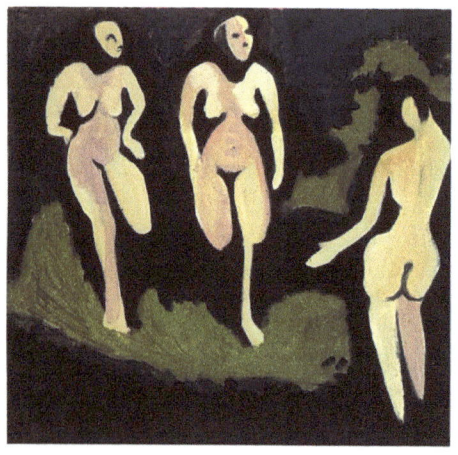

Nudes In A Meadow--
1929

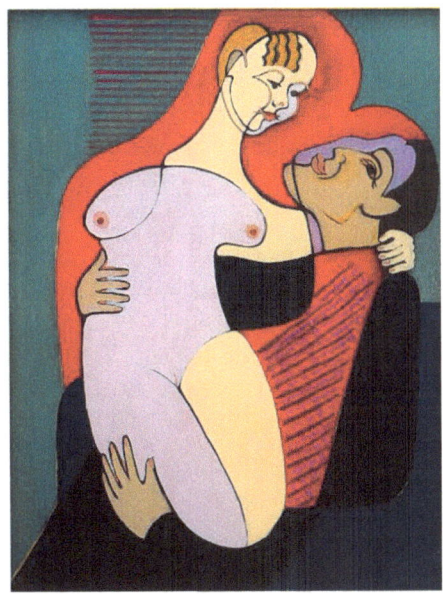

Great Lovers (Mr And Miss Hembus)

1930--Cubism

Reclining Nude In A Bathtub With Pulled On Legs--1930

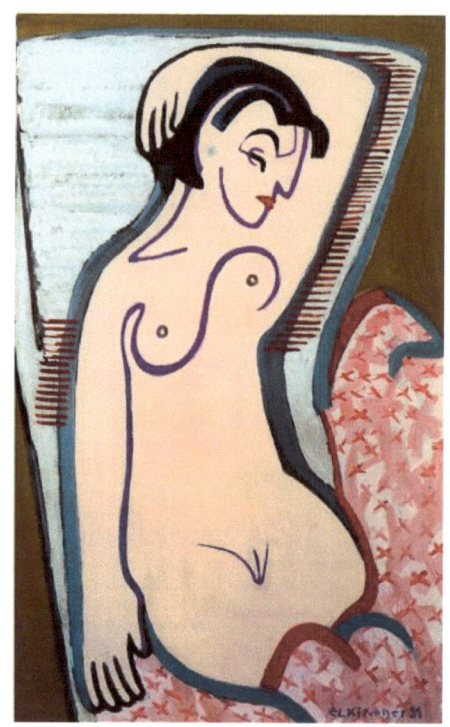

Reclining Female Nude—1931

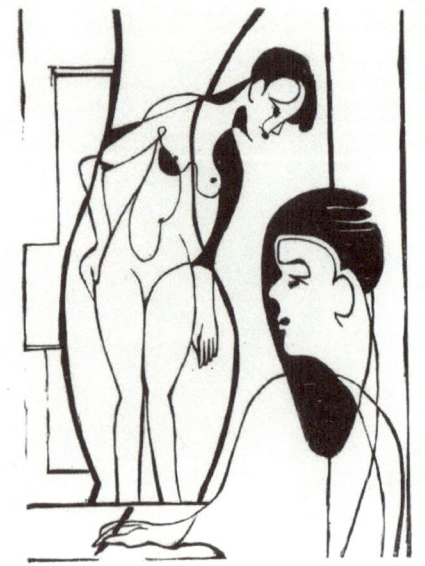

Artist And Female Model--1933

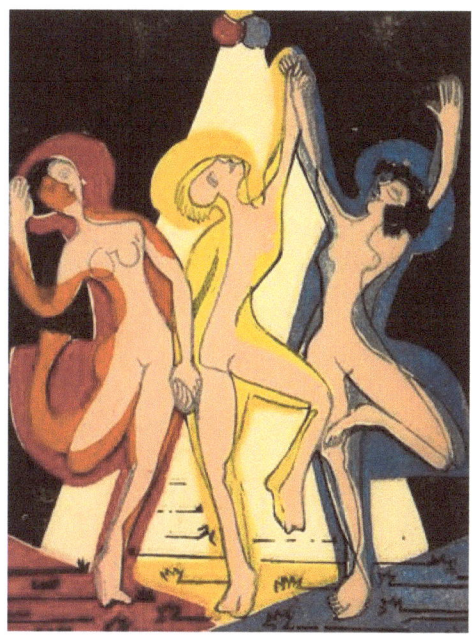

Colourful Dance--

1933

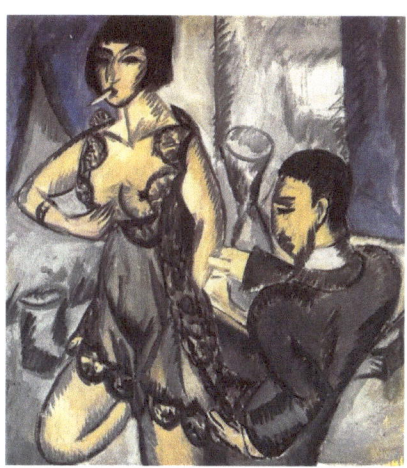

Couple In A Room

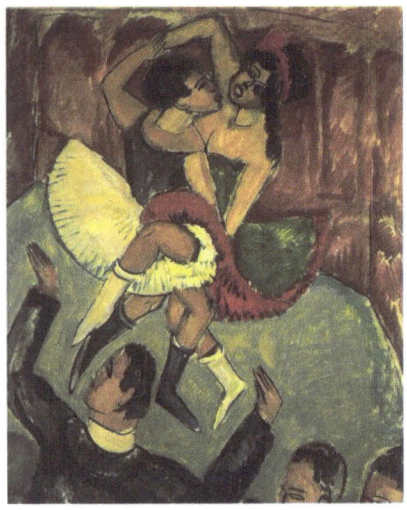

Dance Of Negros

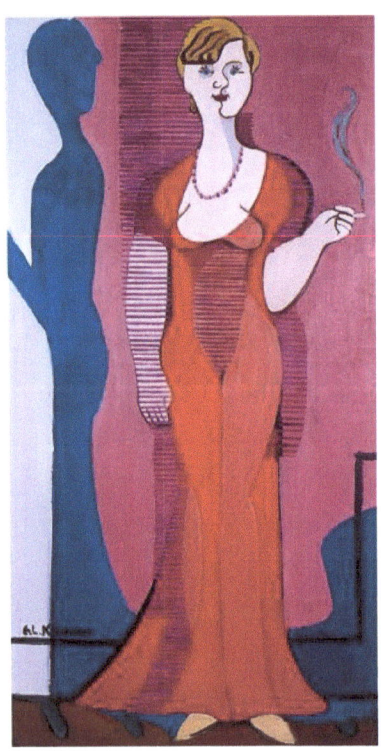

Blond Woman In A Red Dress, Portrait Of Elisabeth Hembus--1932

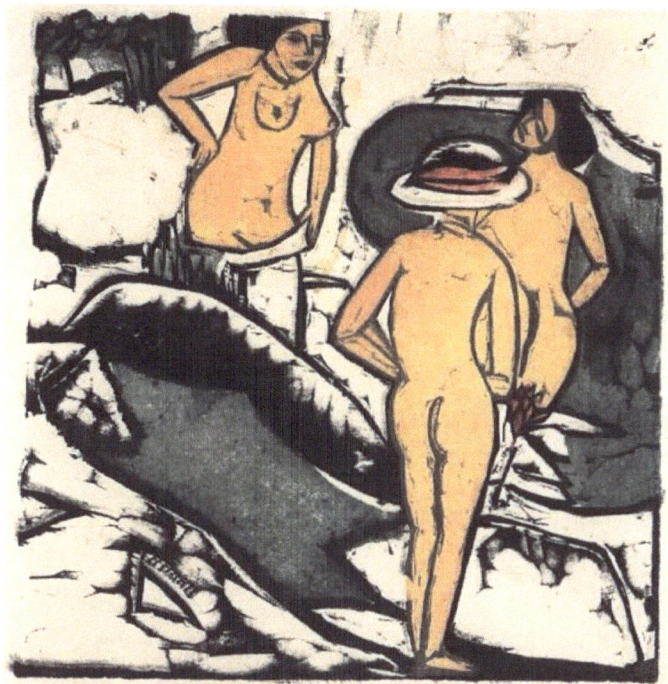

Bathing Women Between White Rocks

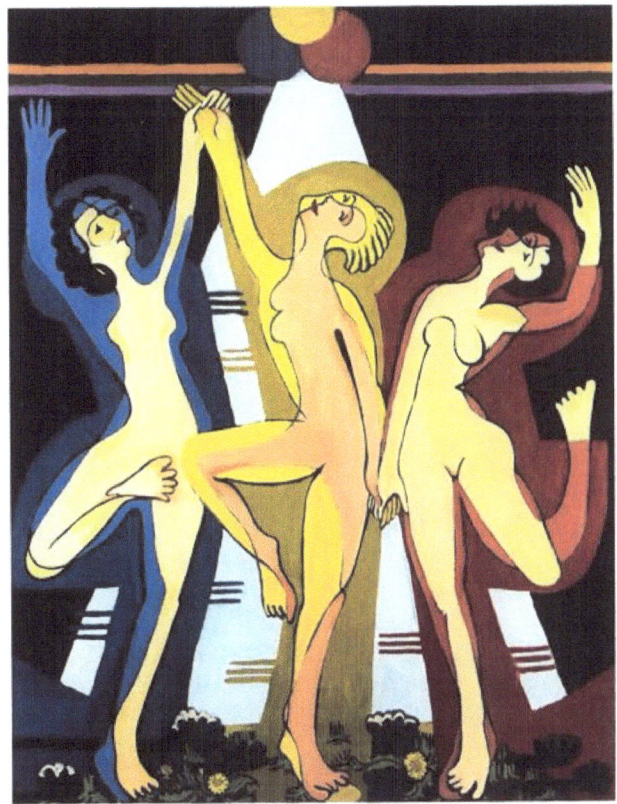

Colourful Dance

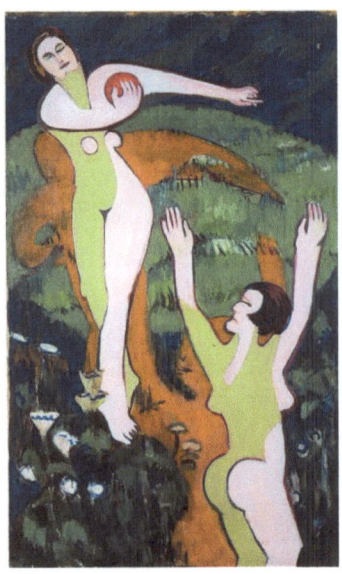

Women Playing With A Ball
1931-1932

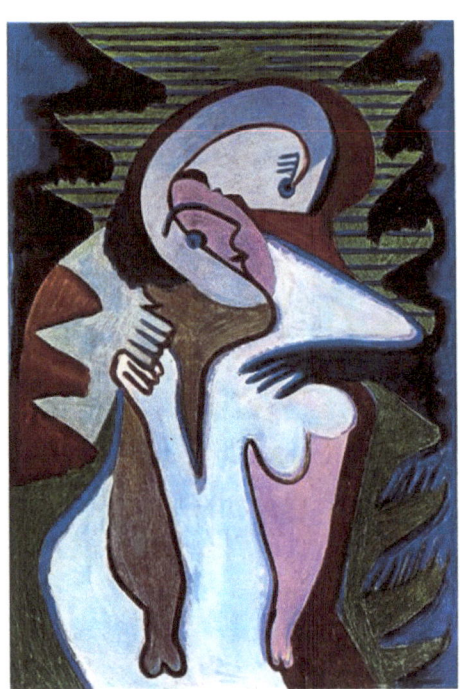

Lovers (The Kiss)—1930-- Cubism

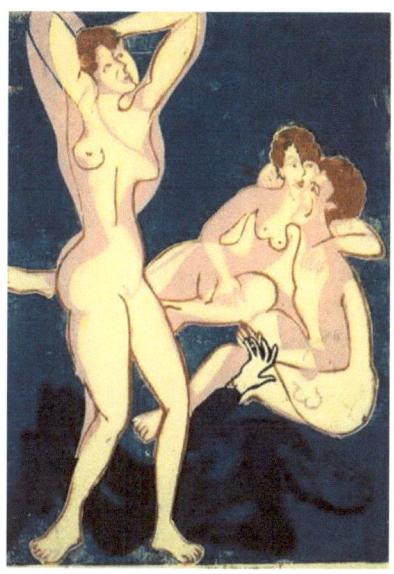

Three Nudes And Reclining Man--

1934

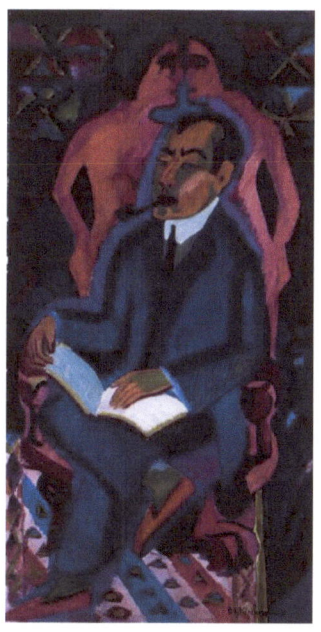

Bathers On The Lawn

Portrait Of Art Dealer Manfred Shames

1925-1932

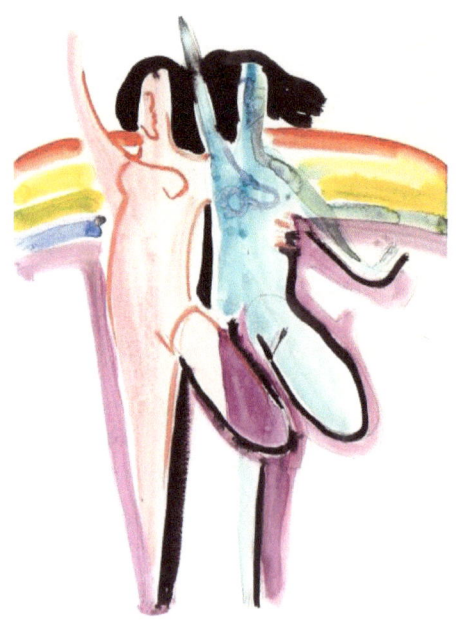

Design For The Banquet Hall In Essen

1932-1933

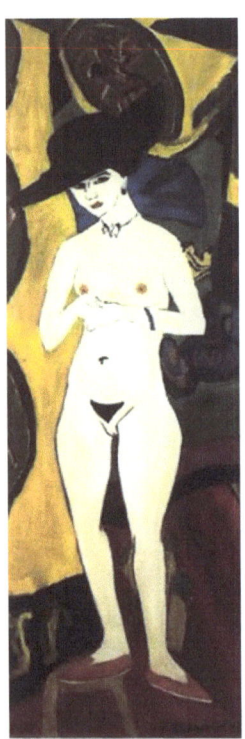

Female Nude with Black Hat

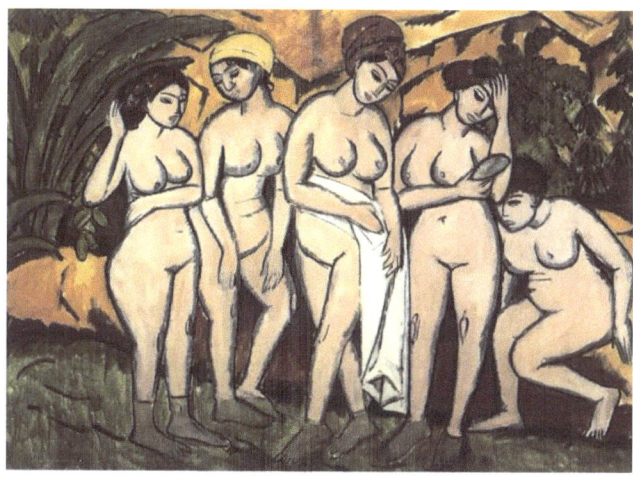

Five Bathing Women At A Lake

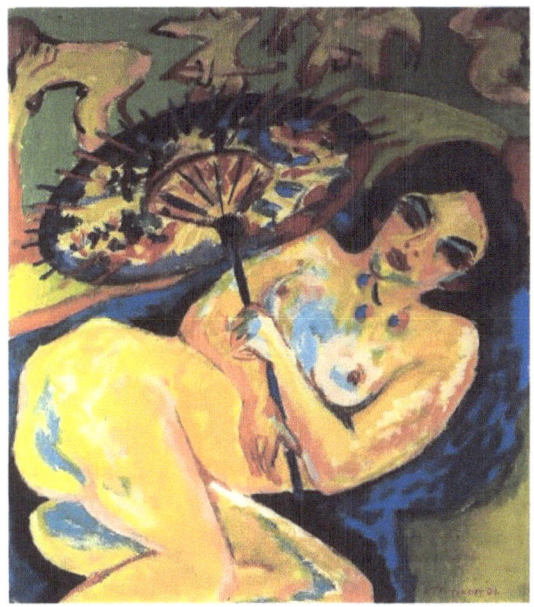

Japanese Parasol

Female Dancer 1933

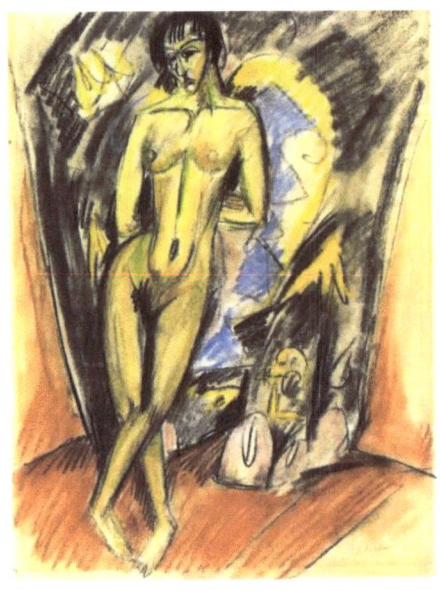

Standing Female Nude In Front Of A Tent

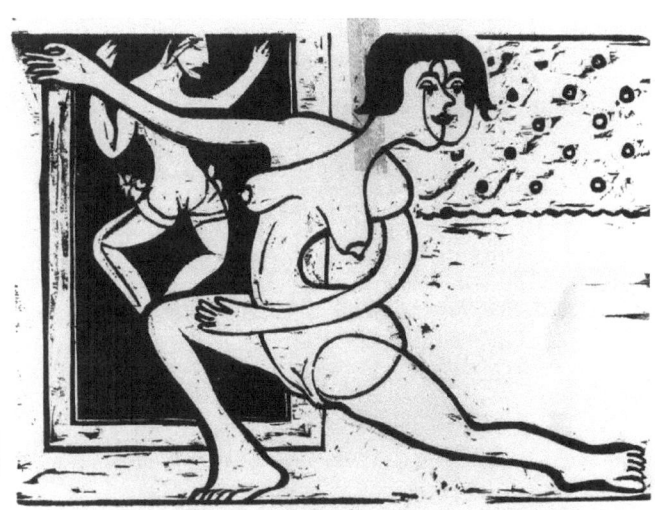

Practising Dancer
1934

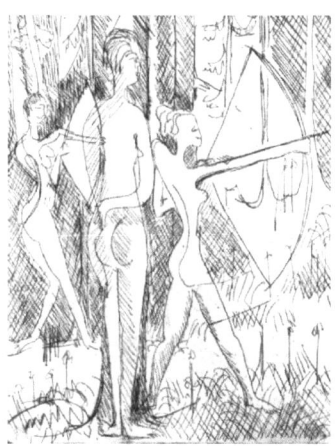

Arching Girls In The Wood--1934

www.ingramcontent.com/pod-product-compliance
Lightning Source LLC
Chambersburg PA
CBHW050404180526
45159CB00005B/2148